The Brotherhood of District 23 Coloring Book

Copyright © 2016 by Amy Briggs
www.AmyBriggsAuthor.com

Cover and illustrations by: Jessica Hildreth
www.JessicaHildrethDesigns.com

All rights reserved. No part of this book may be reproduced in any form by any electronic or mechanical means including photocopying, recording, or information storage and retrieval without permission in writing from the author.

Printed in U.S.A
ISBN 13: 978-1540487162

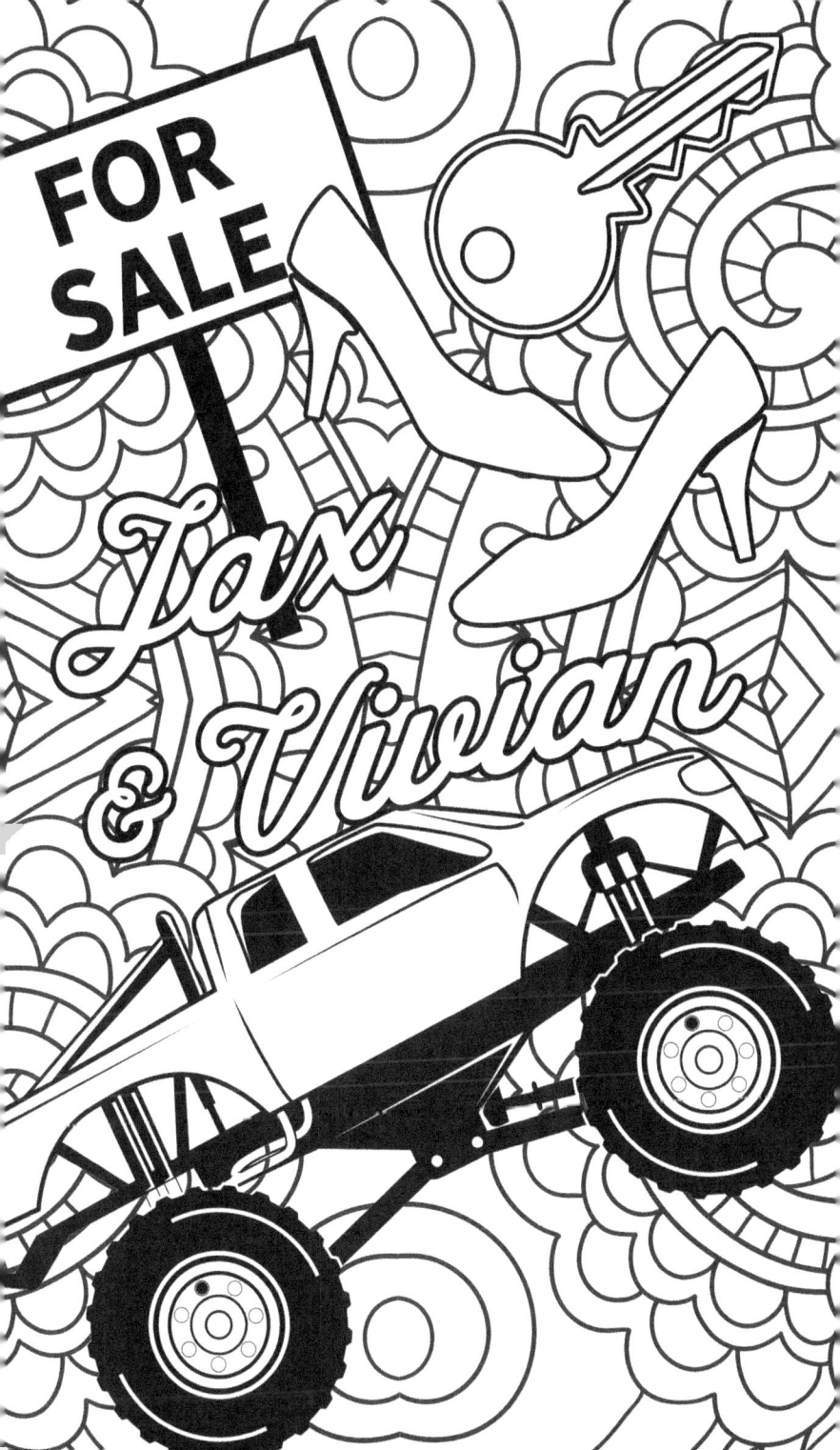

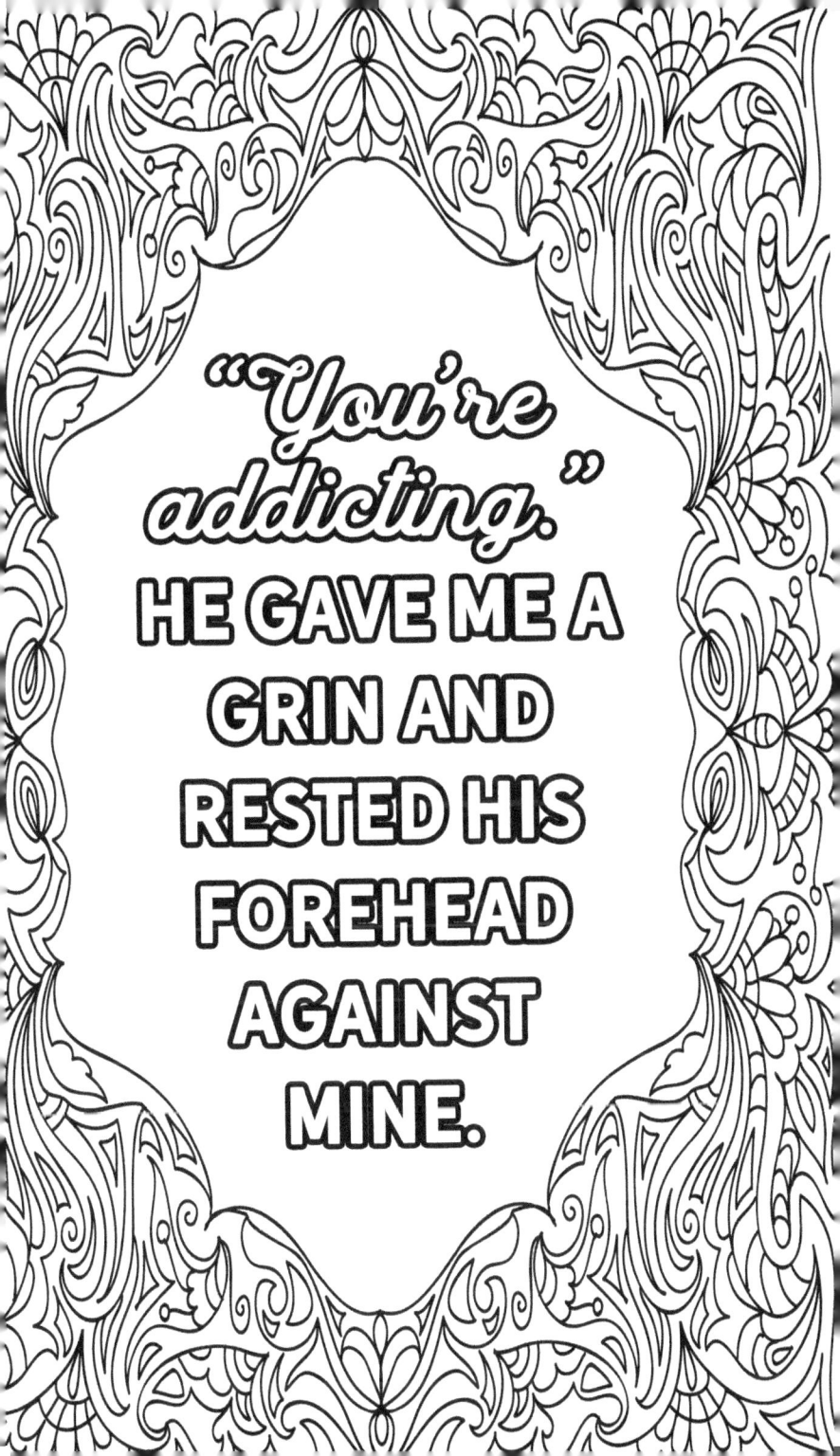

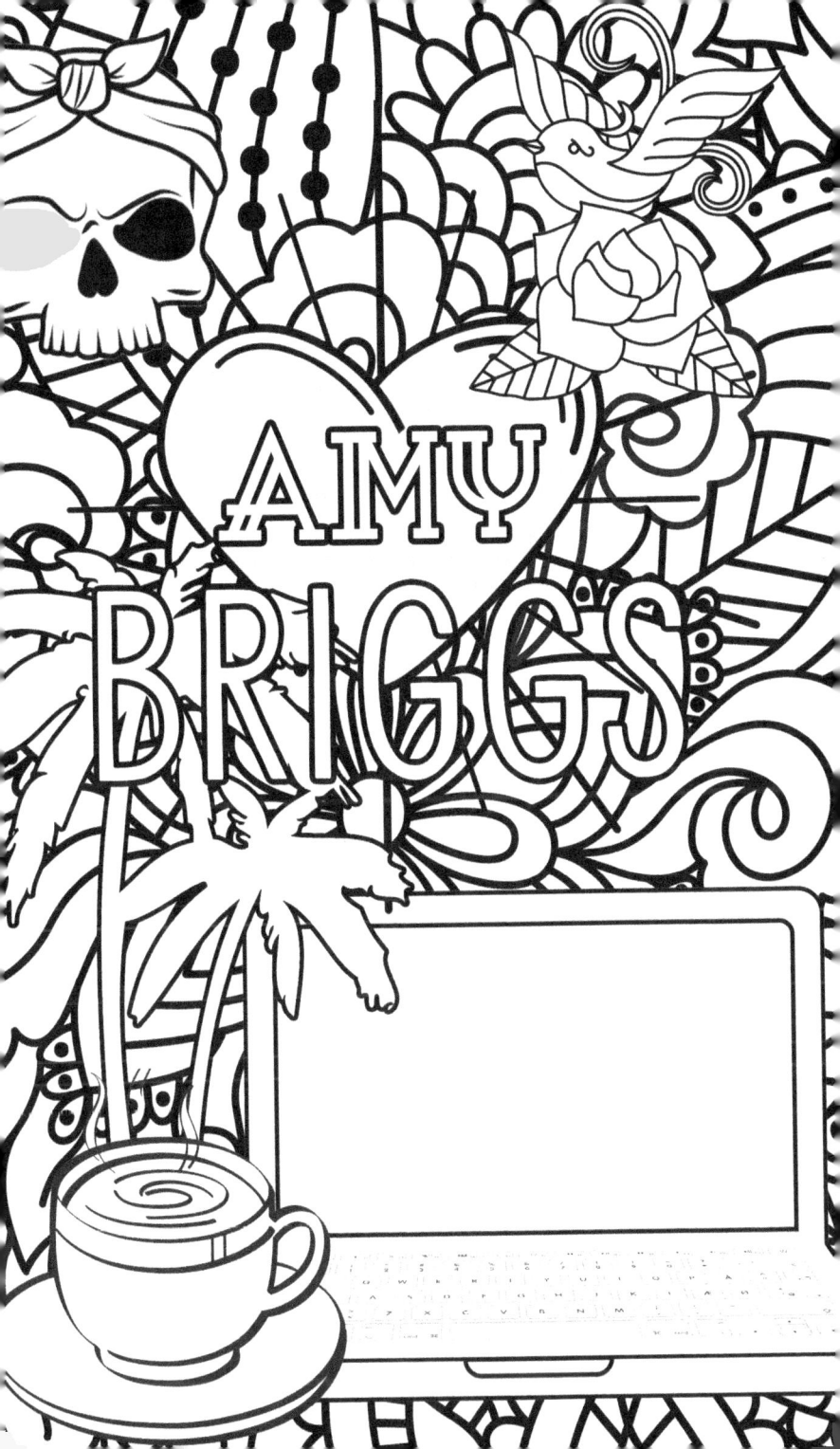

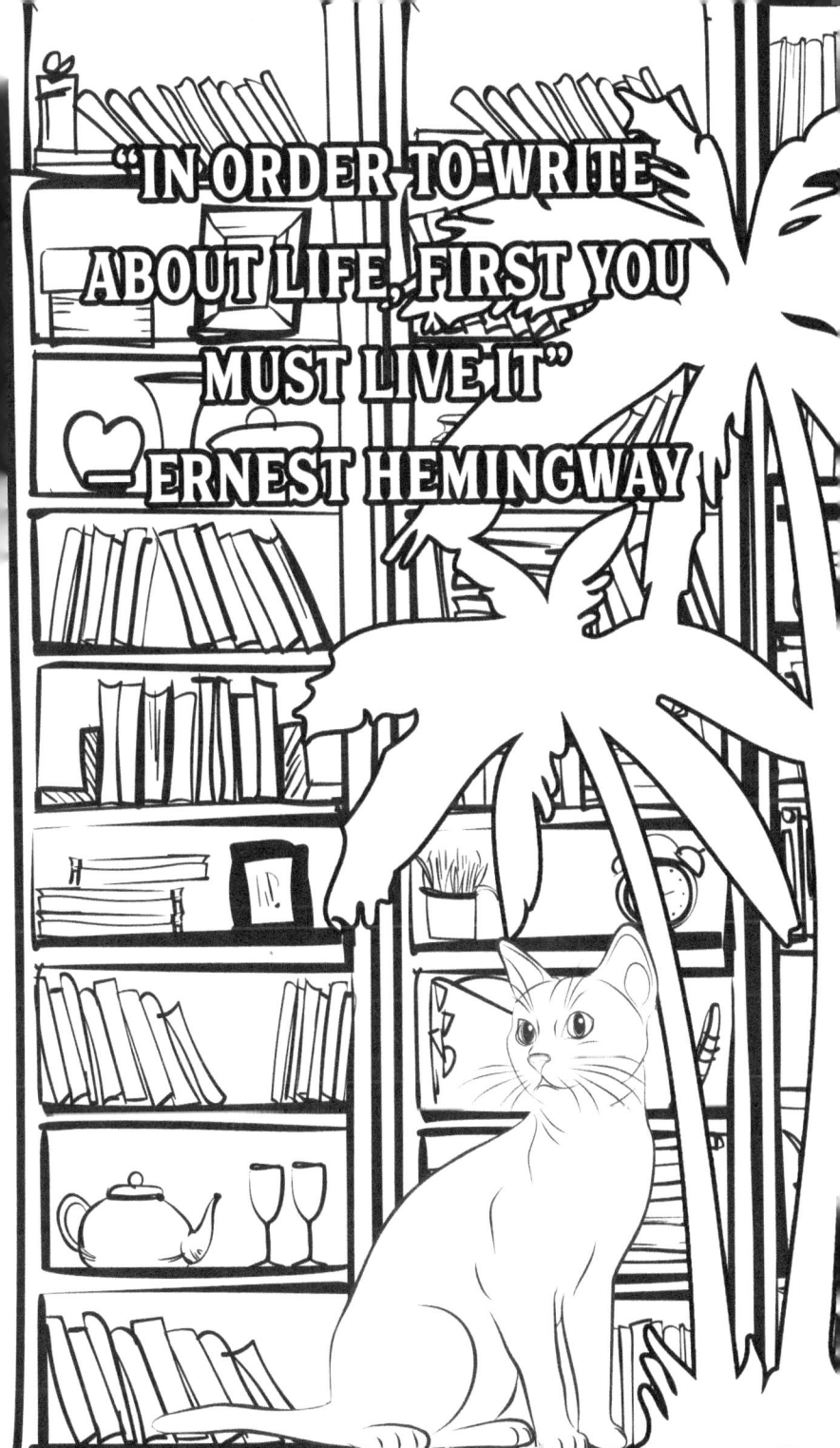

www.ingramcontent.com/pod-product-compliance
Lightning Source LLC
Chambersburg PA
CBHW070721210526
45170CB00021B/1400